THE POTTY TRAINER
THE ULTIMATE GUIDE TO POTTY TRAINING YOUR CHILD

D. Preston Smith MD
Pediatric Urologist
Fellow of the American Academy of Pediatrics
Fellow of the American College or Surgeons
Fellow of the Society of Pediatric Urologists

Foreword By:
John Neece Ph.D., J.D.
And
Janis Grimes Neece Ph.D.

PottyMD™
Helping kids to stop and to go.

The content and information contained in this book are intended to help parents and physicians with potty training issues. The content and information in this book does not constitute professional medical advice and should not be substituted for professional medical advice, diagnosis, and/or treatment. The author and PottyMD LLC disclaim any liability arising from use of the content contained in this book.

Printed in the United States of America

PottyMD LLC
Knoxville, Tennessee USA
www.pottymd.com

ISBN 0-9762877-0-6

Subject: Parenting/Childcare, Potty Training/Toilet Training

Book Design: Layne Moore
Cover Design: Mary Revenig
Illustrations: Denise McClure

Bulk order discounts are available for medical practices, parent organizations, or other interested groups. Please contact PottyMD.com for more information.

ABOUT THE AUTHOR

D. PRESTON SMITH MD, FACS, FAAP, FSPU
Pediatric Urologist

D. Preston Smith attended Rice University where he graduated with honors in Economics. He attended the University of Texas Medical School at Houston and following graduation he spent two years in General Surgery at the University of Tennessee Medical Center at Knoxville. In 1993, he finished his Urology Residency at Northwestern University in Chicago. He concluded his training upon completion of a two-year fellowship in Pediatric Urology at the University of Tennessee at Memphis and LeBonheur Children's Hospital in 1995. Dr. Smith is board certified and he has authored or co-authored many articles, papers, chapters, and books in Urology and Pediatric Urology. His research has been presented throughout the world.

Dr. Smith is married and is a father of three young children. He currently maintains a very busy pediatric urologic practice. He is a fellow of the American Academy of Pediatrics, American College of Surgeons, and Society of Pediatric Urology. His dedication to helping children with urologic problems inspired him to establish PottyMD. Dr. Smith hopes through PottyMD to aid thousands of children, families, and physicians by educating them about issues related to potty problems in children.

PottyMD was established in 2003 by pediatric urologists to help physicians, parents and children with all types of potty issues. We are continually studying new methods to help children overcome potty problems. We believe the products we offer are the best and most affordable available. PottyMD continues to research new educational tools and products and we will make them available as they meet our standards.

PottyMD is dedicated to helping children overcome all bladder and bowel issues including:

- Potty training	-Urinary tract infections
- Daytime accidents	-Holding
- Bedwetting	-Belly pains and cramps
- Constipation	-Urinary frequency
- Encopresis	-Urinary urgency

1-877-PottyMD <u>pottymd.com</u>

This book is dedicated to all the frustrated parents who lost hope of ever potty training their toddlers and assumed their children would remain in diapers forever, and to their children who have been forced to endure countless numbers of unsuccessful potty training attempts.

Acknowledgements

Many, many thanks to Kyla Melhorn RN and Sydney Ford LPN for their endless support and contributions to this book. Thanks to Denise McClure for the outstanding illustrations.

TABLE OF CONTENTS

CHAPTER 1...12

INTRODUCTION TO POTTY TRAINING..12

CHAPTER 2...14

POTTY TRAINING BASICS ...14

CHAPTER 3...16

NORMAL POTTY CONTROL DEVELOPMENT16

CHAPTER 4...19

BLADDER, BOWEL, AND SPHINCTER FUNCTIONS.........................19

CHAPTER 5...24

WHEN IS A CHILD READY TO BE POTTY-TRAINED?24

CHAPTER 6...29

SIGNS OF READINESS...29

CHAPTER 7...30

SHOULD YOU DELAY POTTY TRAINING?...30

CHAPTER 8...31

PROS AND CONS FOR EARLY TRAINING...31

CHAPTER 9...32

APPROACHES TO POTTY TRAINING ..32

 CHILD-DIRECTED APPROACH ...32
 PARENT-DIRECTED APPROACH..33
 BLENDED APPROACH ...35
 SUMMARY ..36

CHAPTER 10..37

SPECIFIC POTTY TRAINING APPROACHES37
POTTY TRAINING IN A DAY..37
NAKED CHILD APPROACH ..38

CHAPTER 11..40

POTTY TRAINING TIPS..40

CHAPTER 12..42

DIAPERS AND PULL- UPS DURING POTTY TRAINING42

CHAPTER 13..44

THE FIRST TIME YOUR CHILD USES THE POTTY............................44

CHAPTER 14..46

REFUSING TO POOP IN THE POTTY..46

CHAPTER 15..51

TEACHING YOUR CHILD GOOD POTTY HYGIENE51

CHAPTER 16..53

SETBACKS AND WHY THEY HAPPEN ...53

CHAPTER 17..56

THE RESISTANT CHILD..56

CHAPTER 18..59

REWARD SYSTEMS ..59

CHAPTER 19..61

BEDWETTING ..61

CHAPTER 20..63

KEEPING YOUR CHILD POTTY TRAINED ..63

 BASIC PROGRAM ..64
 PROGRAM HELPERS..66

CHAPTER 21..68

CHILDREN WITH SPECIAL NEEDS ...68

COMMONLY USED MEDICAL WORDS..................................72

RESOURCES..77

FOREWORD

Advice for parents is in great supply these days. Bookstore shelves house scores of books on all kinds of parenting topics. Generally the experts claim to have the right answer. It's tempting to think that you need a Ph.D. in something to be a wise parent.

In fact, we did have Ph.D.'s (in psychology, no less) when our first child was born. We found out quickly that two psychologists are no match for a toddler. Being accustomed to doing research, we decided to read the experts' advice whenever we hit a snag.

But which expert to trust? The one who said sleep with your baby, or the one who said let them cry in the crib? The one who said feed on a schedule, or the one who said go by your child's signals? The one who said potty train in a day, or the one who said let the child lead the process? Each one left us feeling we were making a horrible mistake if we didn't toe their line.

How easy for today's parents to be overwhelmed by advice and to lose trust in the instinctual feel for their child!

Preston Smith believes in the power of today's parents to make the best decisions for their child and family. While understanding that we, as parents, may need information and guidance, he empowers us to seek and use the information that best fits our particular circumstances. He realizes that each child, each family, is unique. There is no one "cookbook" recipe that works for all children.

In this book, Dr. Smith provides parents with a *variety* of approaches to go about potty training. He will help you to understand what the process involves, both physically and psychologically, so you, as the expert on your child, can apply the tools that best fit your unique child.

Dr. Smith helps us to see that successful potty training need not be confined to a specific age. Further, successful potty training does not merely involve staying dry or clean for a certain number of weeks. It is a process. Dr. Smith discusses the importance of the child's ability to understand body functions and the need for the child to be ready to follow through on that understanding. He helps us parents understand and deal with the setbacks that often occur. Further, he offers excellent guidance concerning good "potty hygiene" for children of all ages. This is behaviorally sound advice.

Those of us who know Preston personally know how his voice and manner can put parents and children at ease. As a parent, you will be at ease when reading this book. While Dr. Smith offers important medical information, he does not speak over our heads. The information he provides us is practical, useful, and understandable. Let this book guide you to apply the potty training strategies that best fit your own child. And, if you run into roadblocks, pick the book up again knowing, as Dr. Smith proclaims, that such roadblocks are to be expected. Dr. Smith will empower you---the expert on *your* child--to decide whether or not that child is ready for potty training and what approach is most practical for your family.

John Neece Ph.D., J.D.
Psychologist

Janis Grimes Neece, Ph.D.
Psychologist

CHAPTER 1

INTRODUCTION TO POTTY TRAINING

One of the toughest challenges parents face is helping their child through the potty training process. Almost every day parents and grandparents ask me for potty training advice. They want to know the "best" way to toilet train a child. My responses vary depending on the situation and the child. I do not feel there is a "one size fits all" method of potty training. I tell them there are many excellent ways to potty train, and the best method for their child is the one that works. Not all children will respond to the same approach. My wife and I found we had to take a slightly different approach with each of our own three children. Each child is a unique little individual and each family has its own unique dynamics. What brings results for one child may bring only frustration to another.

Everyone is an "expert" if you ask for potty training advice. Many pediatricians, family doctors, psychologists, and child specialists have ideas on how to proceed with the potty training process. Some recommend parent-directed methods with somewhat stringent guidelines, while others feel the child should have most of the input concerning when and how she is trained. The fact is you are the one who knows your child best. Do not let someone else tell you that you must use a method that does not fit your child's temperament, your parenting style, or your family's lifestyle. Follow your instincts and be prepared to be flexible. If you hit a brick wall, stop for a while and try to figure out why, make a new plan, and begin again. Your child's readiness is no indication of his intelligence or your parenting skills, so if your neighbor's child achieves potty training success before yours does, don't take it personally. In a few years, your child may be skillfully riding a bicycle while his playmate is still using training wheels. Rest assured that it will happen when your child is both physically and emotionally ready.

In summary, there are many approaches that can be tried—some successful, others not so successful. Each kid is different, and each approach is different. What works for one family may not be acceptable to another family. Some children respond to potty training techniques with excitement, while others are not willing to try. The process may be fun and it may be frustrating. Relatives and friends will be anxious to prescribe their way to potty train for your child. You will need to decide which

ideas and methods fit your parenting goals and lifestyle. Keep it in perspective—it is only potty training. It is not a test of your parenting skills.

I hope this book will serve as an invaluable resource, filled with suggestions, approaches, and new techniques that will help you and your child have a positive experience as you make this important transition. In reading this book, you will learn many things that are not provided in other potty training manuals. These include:

1) Understanding the strong interrelationship between urine and bowel functions
2) Realizing the parent is in charge
3) Keeping your child toilet trained
4) Avoiding other potty problems after training.

Read, be open-minded, and look forward to beginning the approach that you select to be the best for your child.

I wish you well as you begin your potty training adventure.

D. Preston Smith MD, FAAP, FACS, FSPU

CHAPTER 2

POTTY TRAINING BASICS

It is common for parents to want their child to be potty trained. Pressures from others can cause parents to push for potty training even though it has not been a concern of their own. If you sense pressures from outside individuals or institutions, think about the source before forging on with the potty training process. Preschools and daycares may require a child to be potty trained before they can attend. The process of changing dirty or smelly diapers can get old, and parents look forward to getting beyond the diaper years. The costs and inconveniences of needing diapers can cause families to wish their children were potty trained. If other children of similar ages are potty trained, then parents begin to think their child or their parenting skills are flawed, and the frustration can lead a parent to take undesirable actions. **Toilet training difficulties have been cited to be a leading cause of serious child abuse and death in children over the age of one.** Parents are naturally exposed to many or all of these issues that may cause them to make potty training more of a priority than it needs to be.

Many parents ask, "At what age should my child be potty trained?" There is no set age by when a child should be out of diapers. Different social standards exist for different people. None of these standards takes into account all of the factors that are involved in raising your child. Set your own timeline; try not to be pressured when others believe your child should already be potty trained. You should determine the most appropriate time to train so that you can approach toilet training with confidence and enthusiasm and without hesitancy.

Potty training your child should not be a big deal. It should be something you approach with excitement and optimism. If you feel it may not be the best time to potty train your child, then it is probably not. Follow your parental instincts and begin the potty training process only when you feel that you and your child are ready. Society can place undue pressure on us to potty train our children, and if we give in to this and find that our children are not yet ready, we may end up regretting it. On the other hand, do not bury your head in the sand. Don't wait around for that perfect moment when your child comes to you claiming that she is ready to go potty. That perfect moment may never arrive. However, if you feel that

your child is ready, press on, but if others or you are making it a top priority, sit back and make sure it is not becoming a bigger deal than it actually should be.

Potty training your child should not be a big deal. It should be something you approach with excitement and optimism.

CHAPTER 3

NORMAL POTTY CONTROL DEVELOPMENT

Before we get to the heart of potty training issues, it is important to have a basic understanding of bowel and bladder control and the correlation between the two. Once you develop an understanding of what normally happens with urine and bowel control, then you can better visualize the inner workings of your child's body as he moves through the potty training process. If you encounter difficulties along the potty training path (and most parents do), understanding the normal bodily functions may help you resolve these problems more easily. A basic knowledge of the interrelationship between bladder and bowel function will educate you on the importance of instilling good potty habits from the beginning of the toilet training process. This will result in helping your child to avoid potty problems in the future.

> **In this book you will learn the** interrelationship between bladder and bowel functions. **This will result in helping your child to avoid potty problems in the future.**

Most parents are familiar with the routine of feeding formula or breast milk to a newborn baby, and then either during the feeding or shortly afterward, it's time for a diaper change. Newborns have reflex emptying of their bladder and bowel. In other words, when the bladder or rectum fills to a certain point, they empty automatically. This spastic, non-voluntary emptying occurs due to the immaturity of the baby's digestive system. That is why there are frequent wet and full diapers in most babies. Their diet of formula and breast milk also contributes significantly to frequent bowel movements. As the infants grow, their diet changes to more solid foods, and their bowel movements become more bulky. They are also beginning to understand their bodily functions, and they may start to experiment with holding their urine and stool. Natural growth and making and storing more urine and stool will result in stretching the bladder and large intestine (colon). As a result, the infant is able to hold more, and the intervals between emptying their bladder and bowel become longer.

As children mature to the toddler stage, their frequency of emptying may decrease. This is largely due to the fact that toddlers are able to store more urine and stool than newborns. Depending on their diet and fluid intake, they may have a wide variety of bladder and bowel movements. Also, the capacity of the bladder and bowel varies from child to child, requiring some children to go more often than others. As a general rule, toddlers will urinate 4-8 times a day and have 0-2 bowel movements a day.

Bowel movements become more sporadic and variable among children of this age because stool is solid and more easily controlled than urine. Other factors that may play a role in frequency are the sociability and mobility of toddlers. This may encourage them to delay or avoid urinating or having a bowel movement in order to avoid having their diapers changed (I believe young children are smarter than we realize). Also, diaper rashes can cause children to develop patterns of holding if the child associates diaper changes or elimination with pain. Diaper rashes can be painful, especially when they come in contact with urine and stool. For this reason, diaper rashes may cause a toddler to hold his urine or stool longer, especially if he thinks that wet wipes, washings, and even ointment application will be painful.

Some psychologists tend to think that toddlers hold their pee and poop because these are two of the few things that toddlers can actually control. There is possibly some validity to this explanation, but it is not within the scope of this book to explore this explanation further. Suffice it to say that toddlers show a wide variety of bladder and bowel function, some of which can be explained by purposeful holding.

Toddlers often learn to hold their urine and stool before they can figure out how to eliminate it voluntarily. By the time children are between eighteen months and three years, they are usually experimenting with holding and emptying on a regular basis. In some cases, you will begin to see physical signs that your child is holding. Squatting (posturing), grunting, or hiding can signal a full bowel while "dancing," leg crossing, or diaper tugging can indicate a full bladder. However, just because your child experiments with holding and emptying does not mean he will understand what is expected of him during the potty training process. Children can become very confused and even discouraged, especially if they develop pain with bladder spasms or bowel cramps from holding too long or not completely emptying. The biggest difficulty is that they cannot usually describe what they have done or what kind of pain they are having because of limited

vocabulary. If this occurs, it can lead to frustration between the child and parent. Patience and understanding are needed as children begin to sort through the basic concepts of potty training. Parents should keep in mind that children less than two or three can experiment with holding their urine and bowel for extended periods of time, and this behavior can and often does transfer into the potty training process.

Children can become very confused and discouraged, especially if they develop pain with bladder spasms or bowel cramps from holding too long or not completely

CHAPTER 4

BLADDER, BOWEL, AND SPHINCTER FUNCTIONS

Let's spend a few moments discussing normal bladder and bowel functions to enable you to understand what you're dealing with and how easily confused a child can become during the potty training process. In order to store urine, the bladder relaxes much like a balloon and holds relatively large volumes of urine under low pressure. Bladder pressure does not start to increase significantly until the bladder gets near capacity. While the bladder is storing urine, the doughnut shaped muscles (sphincters) that wrap around the urethra (tube that lets urine out of the bladder) are tight so that urine does not leak. There are two sphincter muscles, one that we cannot tighten or control and one that we can. When children tighten their pelvic or bottom muscles they are contracting one of these sphincters. When the bladder gets full, we feel the sensation to urinate. By contracting (tightening) one of the sphincters the urge to urinate can be suppressed, which allows for more time before needing to potty. When urinating, children relax the tightened sphincter muscles, enabling them to eliminate.

Bowel movements are similar, but they sometimes require straining to move the stool into the rectal area. This then requires some relaxation and dilation of the anus before the flow of stool occurs. The pelvic muscles that control the sphincter must be relaxed to effectively empty both urine and stool. When finishing, the pelvic and sphincter muscles are intermittently contracted and relaxed so the bladder and lower bowel can empty any residual urine or stool. Once completely finished, the pelvic muscles and sphincters will reestablish the tone that is required to once again store urine or stool.

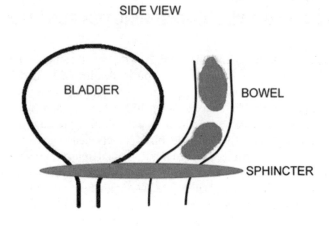

SIDE VIEW

BLADDER

BOWEL

SPHINCTER

This normal process is a very effective way to empty and store urine and stool. Since the bodily functions involved with urinating are similar to having a bowel movement and vice versa, we are most likely to have a bowel movement when we are voiding—we pee and poop and then pee and poop again until empty. The fundamental concept of realizing the close relationship between these two processes is important to understanding normal potty control development in children. In summary, as the bladder stores urine the sphincter muscles are tight, and when urinating the pelvic muscles relax and the bladder contracts and pushes the urine out. This is similar, but not exactly the same process involved with having a bowel movement (see illustrations).

BLADDER STORING URINE

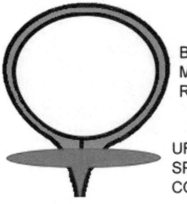

BLADDER
MUSCLE
RELAXES

URETHRAL
SPHINCTER
CONTRACTS

NORMAL BLADDER EMPTYING

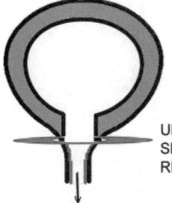

BLADDER
MUSCLE
CONTRACTS

URETHRAL
SPHINCTER
RELAXES

BOWEL STORING STOOL

RECTAL
SPHINCTER
CONTRACTS

NORMAL STOOL EMPTYING

RECTAL
SPHINCTER
RELAXES

Just as some individuals are born with big feet or long arms, some children are born with large bladders and bowels. The size of the bladder or colon can be a physical variant that affects what problems a child may or may not have with potty training or future potty habits. If a child is born with a large bladder or bowel it does not necessarily mean that it has been stretched or is abnormal, but a large bladder may be harder for a child to empty or it may result in longer intervals between potty visits. If the colon, or large intestine, is large (dilated), then less frequent bowel movements or mild constipation may occur. The differences in bladder or

bowel size are usually not significant, but must be taken into account when trying to explain some of the different problems children experience when trying to potty train.

> **Warning:** In order to avoid confusion among those trying to help a child with potty training problems, the understanding of normal bladder and bowel functions is extremely helpful.

Since not all health care providers completely understand the processes involved with urinating and having a bowel movement, it is not expected of parents to routinely know how to correct their child's problem. The information provided in this chapter should allow any parent to have a basic understanding of their child's bodily functions. You should contact your child's doctor if more help is wanted. A pediatric specialist can provide even more expertise if needed. There are "tricks of the trade" that physicians have used to overcome difficult potty problems. For example, I will commonly treat children that have only urinary symptoms with a bowel program. The reason for this is we do not currently have any medicines or surgeries that will make a child urinate well and completely empty the bladder. But if we give them a mild laxative or an aggressive bowel program we turn them into "super poopers." A child who is having frequent bowel movements will usually urinate more often and empty his bladder more effectively. By virtue of controlling and regulating his poops we regulate the processes by which he works with his pelvic muscles and relaxes and empties well. By turning children into super-poopers they can become super-peeers!

Super-poopers=Super-peeers

CHAPTER 5

WHEN IS A CHILD READY TO BE POTTY-TRAINED?

The Million-Dollar Question

The rate at which a child develops is unique for each child. Some children are ready to be potty trained at a young age. Children as young as eighteen months can show the signs of maturity and physical capabilities that are necessary to be potty trained. Other children may take longer and not be ready until three or four years of age. The age a child potty trains does not reflect her intelligence or future maturity. Just because a child can physically get on and off a potty or even take off her diaper and clothes, does not mean she is ready to begin potty training. Likewise, just because a child talks about going to the potty does not necessarily indicate she is ready. A child will need to have both the physical and emotional capabilities of being potty trained before she is considered ready.

It is unfortunate that many "experts" claim there is a particular age to begin the potty training process. Some experts feel children less than two years of age should not be potty trained. They fear that parents will try to train their child before they are ready. Yes, if a child is being forced to do something before they are ready then there can be adverse consequences. A child can become defiant or even rebellious if they are forced to do something they are not physically or mentally mature enough to do. This can result in long-term problems with parent-child relationships and problems with potty habits after training.

Contrary to what some experts or organizations say, some children are ready to train early. If potty trained correctly, there may be no consequences to training early. There may even be positive personal rewards for the child and family. Anyone who quotes an age for when a child is too young for potty training is probably making generalizations that do not apply to all children. Some children less than two years of age can be safely trained if they show signs they are ready and if the parents' expectations are realistic. If a young child experiences a pleasant potty training experience then he is less likely to experience other potty problems in the future.

Children should exhibit some basic *physical* capabilities in order to begin the potty training process.

- The child should be able to help with the task of taking off his pants or undergarments.
- Your child should be able to assist with taking off the diaper or pull-up when the urge to go hits her.
- Depending on the type of potty used, children should be able to get on the potty in a comfortable position. If a small portable floor potty is used, then young children will be more able to straddle and keep their feet on or near the floor. Using a traditional commode will probably require significant assistance from a parent. Toilet inserts and stepping stools are very helpful when attempting to begin potty training on a regular commode.

Children who are able to physically assist with removing their clothes and position themselves on the potty are probably exhibiting the basic physical requirements that are often needed to begin potty training.

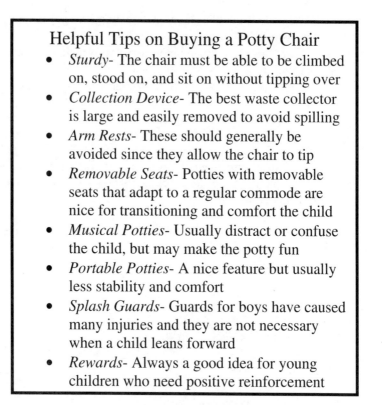

Helpful Tips on Buying a Potty Chair

- *Sturdy*- The chair must be able to be climbed on, stood on, and sit on without tipping over
- *Collection Device*- The best waste collector is large and easily removed to avoid spilling
- *Arm Rests*- These should generally be avoided since they allow the chair to tip
- *Removable Seats*- Potties with removable seats that adapt to a regular commode are nice for transitioning and comfort the child
- *Musical Potties*- Usually distract or confuse the child, but may make the potty fun
- *Portable Potties*- A nice feature but usually less stability and comfort
- *Splash Guards*- Guards for boys have caused many injuries and they are not necessary when a child leans forward
- *Rewards*- Always a good idea for young children who need positive reinforcement

The physical maturity that is required to voluntarily urinate or have a bowel movement is commonly discussed in most educational materials that deal with potty training. It is important for children to be able to control their urine and bowel movements by controlling the actions of their bladder, bowel, and sphincters (pelvic muscles). These organ systems are complex and are learned slowly and over time. Children probably begin to understand some of these functions by simple trial and error. By contracting their sphincters to prevent from urinating or having a bowel movement they begin to sense what it feels like to have a full bladder or colon (large intestine). There is no set age when this occurs. Infants probably have some level understanding of how their body works. To state that potty training requires a child to have the physical maturity to control her sphincter may not be a valid concern. It is probably better stated that children need to be mature enough to want to control these bodily functions. We may never know at what point young children really

begin to understand their bodily functions. It is not until they are old enough to talk and respond to potty training instructions that we realize they are able to control their bladder and bowel. Urine and bowel control may occur at a very young age, but the limiting factor to potty training primarily rests with the child's ability and desire to be instructed on how to best use this ability.

Parents are not always good at assessing when their child is emotionally ready to begin the potty training process. Some children may be able and willing to potty train, but they do not always verbally express this to the parents. If a child speaks or acts in ways that indicate he would like to use the potty, then he is most likely ready to try. Just because they want to, doesn't mean they are willing to do what is necessary to achieve this goal. Some children will try to train before they are able to coordinate all the activities and bodily functions that provide success. But if a child hints he would like to try, then encourage him and give him the opportunity, even if he is young. The signs of readiness will be discussed in the next chapter.

Steps for preparing your child for potty training:

- Allow your child to do independent activities
- Praise your child for independent behavior
- Explain the terms 'wet' and 'dry' whenever changing diapers
- Tell your child it is good to have clean and dry diapers
- Reward or encourage your child when he tells his diaper is wet or full
- Change diapers in the bathroom and flush poop down the toilet
- Have your child watch (and help) you flush the toilet
- Talk about going to the potty-discuss the urge to go
- Show your child how you and others in the family go potty
- Discuss pee and poop habits in your own friendly terms and use these terms often
- Introduce your child to the potty and explain how it works
- Consider getting your child her own special potty so she can sit on it and read etc.
- Have your child sit on their potty while you sit and use the toilet
- Praise your child for sitting on the potty
- Do not initially force your child to sit on the potty

- Make sure your child's clothes are easy to remove—avoid buttons, belts, overalls

If your child is unsuccessful, do not view this as a setback, but do remember to praise your child for simply attempting the challenge. On the other hand, if a child never expresses an interest in potty training, she should still be given the opportunity to attempt to train. Coaxing by the parents is reasonable, especially if the child is mature in other areas. Some children need the ideal setting so they are not easily discouraged or afraid when they do try. For example, parents will need to be more patient and provide extra encouragement to children that seem uninterested. The potty should be comfortable and not intimidating, and explaining and exhibiting normal bladder and bowel movements may be necessary. Rewards and praise typically go a long way. Emotional maturity is difficult to assess in some children, but if a child wants to train, allow them to try. If a child does not want to train, give them a reason to want to.

CHAPTER 6

SIGNS OF READINESS

Children are not always able to express their readiness to be potty trained. You should be aware of signs that might provide hints your child is ready. Basic milestones that exhibit a child's ability to potty train can be exhibited with basic words and actions. Parents may be unaware of these signs unless they look for them. If your child exhibits many of these characteristics then he may be ready to begin potty training. However, you should not attempt potty training just because your child exhibits some or most of these signs. These signs are only intended as guidelines to consider when wanting to potty train your child.

Signs of Readiness:
- Is aware of the need to go
- Can express and understand simple words and commands
- Is able to demonstrate imitative behavior
- Can sit quietly for 4 or more minutes
- Dislikes wet or soiled diapers
- Anxious to please you in any way
- Able to stay dry for 2 hours and wakes up dry after a nap
- Able to pull pants up and down
- Socially aware of friends, and has a desire to be like peers
- Able to tell you that he/she is "about to go"
- Asks to use the potty
- Wets or soils diapers at certain times or places
- Wants to sit on the potty
- Able to sit on the potty
- Describes when they pee or poop

CHAPTER 7

SHOULD YOU DELAY POTTY TRAINING?

Child development specialists often recommend parents to delay potty training when there are disruptive factors in the child's life. Situations such as divorce, new siblings, strange environments, and family death are examples they provide that are not conducive to a "healthy environment to potty train." Children who are distracted or disturbed by surrounding events are less likely to be focused on the potty training process. Attempting to potty train a child that is confused or not able to focus on the task at hand can be frustrating for all involved. Like other "rules" of potty training, you as a parent are able to decide when and how to potty train your child. As long as you realize that children can have fragile and delicate personalities that are easily influenced by their surroundings, then proceed as you see fit. Just be careful to not push potty training when potty training may not be the most important issue currently taking place in your child's life.

Common situations that might be cause to delay potty training include:

- Arrival of a new sibling
- Recent family death
- New home
- New school/daycare
- New babysitter
- Recent significant illness
- Defiant or resistant phase
- Parent relationship problems (divorce)
- Fragile period in life (nightmares, clingy behavior)

CHAPTER 8

PROS AND CONS FOR EARLY TRAINING

Pros
1. Less planning for child care
2. Less equipment (changing tables etc.)
3. Less expense (diapers etc.)
4. Less diaper rash and irritations
5. Less laundry
6. Less nursery and daycare problems
7. Less odor and mess

Cons
1. Waste of time if child is not ready
2. Child may sense failure if not able to potty train
3. May develop a battle of the wills (may hold poops to avoid going)
4. Parental frustration if unsuccessful (a common cause of child abuse)
5. It may take longer to train if several attempts are needed
6. May place undo pressure on siblings if another child trained early

There are good arguments for and against early potty training. Parents who approach potty training with a loving and consistent attitude will most likely not regret any method they choose. As long as your child shows signs she is ready, and you are willing to commit the energy and patience to potty train, then proceed—just proceed with caution, because you may need to change your approach to a different one if you find the original approach is not working.

CHAPTER 9

APPROACHES TO POTTY TRAINING

CHILD-DIRECTED APPROACH
(WATCH, LISTEN, AND WAIT)

The watch, listen, and wait approach is my expression for the approach that allows children to potty train at their own rate and on their own terms. In using this approach, parents should watch their child's behavior for signs of readiness, listen to their words related to going potty, and then wait for their child to initiate the potty training process.

Many child psychologists support this approach because it promotes independence. Dr. T. Berry Brazelton, a well-known pediatrician, advocated this approach in the 1960's. Most professionals who support this approach do not believe children younger than two years are ready and wanting to potty train. They typically argue that the age for potty training starts around two and a half to three years old. The philosophy behind this method is that children all develop at different rates mentally, and if pushed to potty train early they may develop defiant and rebellious behavior problems. They believe potty training should be child-directed. In other words, potty training should proceed at the child's rate and not according to what the parents feel is appropriate.

If children are given the opportunity to determine when they are ready, they will potty train without the stressors imposed by their parents. This may lead to a gradual and time-appropriate process that will alleviate concerns about whether the child is "ready." This, in turn, may prevent some emotional problems in the future. When following this approach, parents should not push the training process and should not make the child feel rushed to get out of diapers but rather encourage independence and follow the child's lead.

Advocates of this method believe that most children want to potty train, but at their own pace. This approach usually requires time and patience since some children may wait until three, four, or even five years of age to complete the training process. This may result in prolonged periods of using diapers and pull-ups. Daycares and babysitters will need to

understand and be willing to work with your approach, which may involve relaxing rules that could push your child into underwear before he is ready.

Parents are encouraged to look for signs that their child may be wanting to potty train and help with any frustrations that might develop. However, parents are discouraged from requesting certain activities and progress to speed up the potty training process. Coaxing is probably acceptable, but the child should not sense any parental pressure. This may force the parents to walk a fine line between providing encouragement and taking some control of the training process away from the child.

Opponents of this approach argue there is no set age when a child should potty train. Some feel children less than two are ready to potty train. They also believe that child-directed activities are not always positive. They contend children are not always mature enough and lack vision to understand the potential consequences of not being potty trained. Children who are allowed to choose their own path and timetable may make decisions that are not in their best interest. Most opponents to the watch, listen, and wait approach feel that parent direction is often needed for important and sometimes difficult life learning experiences, including potty training.

PARENT-DIRECTED APPROACH
(WATCH, LISTEN, AND TRAIN)

Next we'll focus on what I call the "watch, listen, and train" approach. Professionals who support this approach believe parents should observe their child's actions, listen to their words for signs indicating that their child is ready for potty training, and then begin the potty training process. Taking this approach requires parents to be aware of the signs and basic requirements that are usually required to successfully potty train and then take action. Many of these signs and basic requirements are listed throughout this book. Some of the more obvious ones include: ability to undress and remove some clothes, ability to verbally discuss the desire or willingness to use the potty, and physical ability to climb onto and stay on the potty. Once you feel your child has these basic skills, training is then encouraged and diligently pursued.

General steps that are usually followed:
- Discuss potty training and getting rid of diapers

33

- Read child books about potties and potty training
- Exhibit how you, the parent, goes potty
- Introduce the potty, flushing, placing poop in the potty
- Ask your child to use her potty
- Avoid clothes or use underwear so child can "experience" any accidents
- Provide positive reinforcements and praise
- Provide consistency, patience, and persistence

Supporters of this approach feel that good and responsible parenting requires parents to make important decisions (like potty training) for their children. They also feel that parents should be instructing their children, in loving but structured ways, to assure that children abide by parental rules and decisions. This method would also be called a parent-directed approach to potty training.

Applying this methodology allows the parents to proceed with potty training once they feel their child exhibits readiness. Parents are then allowed to actively encourage potty use. Instruction can come from parents, siblings, friends, caregivers, or anyone else involved with the child. Positive reinforcement and consistent direction is commonly used. Parents can lovingly request that their child use the potty rather than asking the child if he needs to go. This method can be approached on a timetable that is convenient for the parent, but if it is done inconsistently or intermittently, then the child may become confused. Diapers and pull-ups are usually avoided during the training process. Going naked or using underwear is commonly encouraged so the child will feel any wetness that occurs with accidents. A loving and caring approach must be maintained throughout the entire potty training period.

This approach can be very successful and result in a child being potty trained in a very short period at an early age. However, no credible professional or child specialist would advocate any approach that forces potty training before the child exhibits basic physical and emotional maturity. If a parent is diligent, loving, and consistent, this approach does usually result in a shorter potty training process in children younger in age than would have taken place otherwise. It provides certain advantages of gaining urine and bowel control earlier. Diapers and pull-ups can be eliminated, thereby avoiding the problems and expense that are associated

with them, and social pressures from other children, families, and friends can be avoided because your child is not delayed in potty training.

Those who disagree with this approach feel children should not be forced to do difficult and potentially confusing tasks at a young age. They also feel potty training should not be overemphasized by parents or society, and when parents force potty training on a child, potentially harmful and hurtful actions can result. They feel younger children that are directed to toilet train do so more slowly than others who do it themselves. This may not only make the entire process more difficult but may cause frustrations to mount and children to develop emotional setbacks along the way. Many will also cite that diapers are now made larger in size and with better absorbency and concealment. As a result, the potential problems associated with wearing diapers for a long period of time are no longer considered an issue. Specific parent-directed potty training approaches will be discussed in the next chapter.

BLENDED APPROACH
(WATCH, LISTEN, TRAIN, AND WAIT)

This approach is probably the technique most commonly used by parents today. As the title implies, this method has the parent watch the child for signs he is ready, listen to what he says about using the potty, attempt to potty train, and wait if he is not yet interested. This method lies somewhere between the two previously described approaches. It is a somewhat less defined method that allows you to wait for your child to show signs of potty training readiness and then intermittently try to see if he can be easily trained. Since it is unwise to attempt training prior to when your child is capable, you should not try this approach (or any approach) until your child exhibits some signs of readiness. However, this method can be used even at an early age to "test the waters."

This blended approach allows parents to introduce the potty and provide encouragement so that their child may become trained earlier. Parents can take an active role in the process as long as they keep realistic expectations and do not become frustrated. If a child views it as an exercise that is fun and exciting, then he may be more willing to try training earlier and on his own. Overall, this process may take longer, but if approached patiently and without a strict timetable, potty training using this method can prove to be less stressful for both parent and child.

35

The blended approach requires patience and understanding, as parents can easily become frustrated by the lack of progress if the potty training is going along more slowly than expected. Parent frustration may lead to child frustration. Children can also become confused if the attempts to potty train are sporadic and deemed unimportant. If the child becomes resistant and is completely unwilling to try, then the parent should stop and resume attempts to train at a later time. This approach may provide for both child-directed and parent-directed methods to meet somewhere in the middle. In other words, a careful balance of both of these methods can complement each other.

SUMMARY

There are several approaches a parent can use to train their child to use the potty. Some techniques advocate a low-key approach using patience and allowing the child to direct the process. Others encourage parents to take an active role in deciding when their child is ready and teaching her normal potty habit behavior. Both extremes are excellent approaches if the parents weigh the pros and cons and formulate a plan that best suits their child's maturity, social settings, and physical concerns. The parent's motivation, time commitment, and social requirements are also factors that should be considered.

Like most aspects of life, there are middle-of-the-road approaches that can be tailored to your situation. Most likely, if you thoughtfully decide on a method to potty train your child, and if you maintain a loving and encouraging environment, then you cannot be faulted on any approach you choose. Be sure to be consistent and be prepared to stick with the program you choose, once you find the correct one, because young children can be easily confused by inconsistency. If the potty training method does not seem to work, or does not fit with your parenting style or lifestyle, then maintain an open mind to change your approach. Forceful and unpleasant approaches will only cause frustration and potentially cause friction among you, your child, and possibly other family members.

CHAPTER 10

SPECIFIC POTTY TRAINING APPROACHES

POTTY TRAINING IN A DAY

A lot of attention has been given to the potty training in a day method. It is appealing to many parents since it appears to be easy and gives quick results. Supporters of this method contend that if a child is ready to be trained, it is more productive to spend an entire day concentrating on the process rather than agonizing over it for weeks or months.

The one-day method outlines very specific techniques to use. To begin this method, you should choose a day to train when there will be no interruptions or distractions. The training is supposed to take place in a room with easily cleaned floors, usually the kitchen. Drinks, snacks and candies should be available for the child. Only one parent should conduct the instruction so that training remains completely consistent and the child does not become easily confused. The child is usually unclothed or lightly dressed with loose clothing so quick placement on the potty is possible. Spending considerable time on the potty is required, and the child may need to be entertained and coached in order to stay there.

The instruction is all-inclusive. The child is taught how to remove the clothes, use the potty and empty the potty, flush, and replace the clothing. Staying on or near the potty during the entire process will help encourage the child by teaching him that he can go in the potty and be rewarded. As long as the parents remain encouraging and diligent, then the child may not view it as a forceful process. The classical teaching of this method included scolding and gentle discipline, but today this is not encouraged. Rewards for success or attempts are typically provided in the form of treats or stickers. This 5-10 hour attempt at potty training can be very effective if parents choose a time when the child is truly ready to potty train and if the child has a desire to please the parents.

Although this method can prove to be successful, it is not without opposition. Several child specialists have spoken openly against this method. It is sometimes viewed as an intensive program that gives parents unrealistic expectations of their child's abilities. It is also perceived as a process that does not allow children any input in the training. Those

against this approach contend that if the child is not "ready" then this intensive instruction will be detrimental to normal parent-child relationships. Opponents say this technique teaches children to go potty only on command and not learn the correct process for themselves. Furthermore, they believe these children may actually take longer to train because they become resistant to forceful instruction.

On the other hand, this was a very common technique that was used when cloth diapers were commonplace. Parents were more motivated to get their child out of diapers. Success was common and some flexibility was usually allowed. At the conclusion, children still loved their parents and many were well trained. The approach instilled good practices and responsible actions in regards to toilet training. All of the aspects of toilet training were usually incorporated with this approach and these included:

- Undressing
- Sitting on the potty
- Emptying the potty (including flushing) and avoiding messes
- Hand washing and good hygiene
- Dressing

Many loving parents continue to use this technique today. Long-term studies have not produced any results that show adverse problems resulting from using this approach in a loving and caring environment.

NAKED CHILD APPROACH

This commonly used approach to potty training involves keeping a child unclothed as much as possible for several days in a row. The philosophy behind this approach assumes children do not like to be wet and loose control of their urine. Variants of this method allow the child to be in underwear (or in underwear with plastic pant coverage) but require the child to continue wearing the underwear for a while even if an accident occurs. In order to try this approach, parents must view this as not being a form of punishment for being wet. Parents must allow accidents to occur without getting upset. If a child is allowed to have accidents without being punished, then a child who is otherwise unaware of their bodily functions can learn valuable lessons. The message of avoiding being wet or having accidents by using the toilet becomes more evident to the child. Children are allowed to learn by observing and feeling, they begin to understand

that urine and stool come out, and they either need to go into the toilet or they will go into the clothes/diaper. This technique can be rewarding for both child and parent since it employs a very simple concept of learning the normal bodily functions and how to avoid feeling wet or sticky.

If a child is not ready to train or is unwilling to change his behavior when an accident occurs, then this approach will be unsuccessful. Continuing to force a child to be wet or have accidents over a long period of time can result in humiliation and resentment. It can be difficult for parents to maintain a loving and encouraging environment if the child continues to have accidents. Children typically need encouragement to sit on the potty, but without this encouragement, this method will likely fail. Children do not always equate being wet with not using the potty. Parental instruction is necessary in order to explain that accidents do occur when you do not use the potty. This approach is very similar to potty training in a day, but it spreads the training over several days and allows the child to learn the causes and effects of using the potty.

CHAPTER 11

POTTY TRAINING TIPS

Potty training experts are everywhere. Whether family, friends, or books are providing you advice, realize there are different approaches that can be tried. An approach that works for one child may not work for another. Others can provide advice, but most likely you know what approach will work best for your child. There are several helpful guidelines (tips) that can be tried for each child when trying to potty train. These include:

- Plan on at least 3 days if you are trying to achieve quicker results
- If you are using a parent-directed approach, arrange your activities and prepare a schedule that will allow you to be patient and consistent—avoid all distractions like going to the store, answering the phone, and dealing with sibling issues
- Make sure spouse, grandparents and babysitters understand your method and plan
- Make sure your child feels they have some control over the process
- Be consistent with your approach and stay with the program unless you are convinced it is not working
- Know when to give up and try at a later time
- Offer lots of fluids so your child will have to go potty more often
- Make going to the potty fun—place safe targets in the potty, decorate the potty, sing
- Praise and reward success AND praise and reward progress
- "Throw a party" the first few times your child uses the potty
- Keep your child company while on the potty
- Start both boys and girls sitting down on the potty
- Make sure the clothing is easy for your child to get on and off
- Do not consider nighttime dryness as a criteria for success during the initial potty training period
- Potty training toys and dolls are excellent exhibitors of what is expected and what happens when urination occurs
- Potty training books and cartoons are fun and informative—they should be read several times
- Have your child watch you use the toilet
- Have your child flush the toilet when you are finished

- Explain poops go "bye bye" when the toilet is flushed
- Avoid talking about the potty or pee/poop as "dirty" or "messy"
- Keep diapers clean and dry at all times so your child gets used to this sensation and wants to avoid a heavy, wet or smelly diaper OR allow your child to where underwear so she can "experience" wetness and hopefully desire to be dry

CHAPTER 12

DIAPERS AND PULL- UPS DURING POTTY TRAINING

Children that begin to use the potty cannot always be trusted to stay dry if placed in underwear. Therefore, it is common for parents to deliberate on whether they should place their potty training child in diapers or pull-ups when in public. Many parents fear their child will have an accident, and they prefer to place them temporarily in diapers when they are away from home. But if they use the diaper, parents also fear their child will not want to go to the potty, and simply regress back into using the diaper. These are very valid concerns and warrant discussion.

Some potty training "advisors" will discourage the use of diapers and others will support their use. Those that discourage diaper use in children who are beginning to use the potty feel that children need consistent practice and guidance to become completely potty trained. They feel that children become confused and potentially frustrated by inconsistent attempts to potty train. If children want to use the potty and they have been rewarded and praised for doing so, then the diaper is a deterrent to allowing them to show their skills and continue their practice. Asking a child to use the potty one place and not another is giving mixed messages. This may only complicate and prolong the potty training process. Training children who try and avoid using the bathroom will experience wetness if they are not allowed to retreat to a diaper or pull-up. These accidents are likely to remind both children and their parents to stay on track to successfully potty train. The experts who support a proactive approach to potty training usually suggest avoidance of diapers in children who show the willingness and ability to use the potty. If your child is successful at using the potty at home, there are few excuses why he shouldn't be able to use the potty anywhere.

Others that support the use of diapers or pull-ups feel that placing too much emphasis on potty training, especially early when the child is not able to consistently be dry, is detrimental to a friendly and low-stress process. They think that children should be spared the embarrassment of being wet and the pressure to perform. These types of circumstances can cause tension between the child and parents. They feel diapers and pull-ups are reasonable tools to use to lower the stress of potty training. Advocates of diapers tend to be those who stress a child-directed approach

to potty training, and they do not believe children should be "forced" to potty train.

After reading the above approaches to the use of diapers and pull-ups in potty training children, most parents can probably view both sides of the argument as reasonable opinions. The advice I tend to provide parents who are frustrated with a prolonged and difficult potty training experience is to avoid diapers as much as possible, even if this requires staying home and focusing on having consistent dry periods with easy and frequent access to the restroom. Once their child acquires the routine of going and staying dry, she is more likely to stay that way. You should be prepared to have frequent unrestricted bathroom visits when away from home. Going without diapers requires you to be prepared for taking your child often, even in public places, and when you have a busy schedule. Spare clothes are necessary for when accidents do occur. Children who are only sporadically encouraged to use the potty will most likely take longer to potty train if the parents are inconsistent with their actions. But you as the parent should choose the approach you feel most agrees with your parenting style and the conditions surrounding your child's potty training experience. Since there is no one correct way to potty train every child, the decision to use diapers or pull-ups is totally up to you.

> **The advice I tend to provide parents who are frustrated with a prolonged and difficult potty training experience is to avoid diapers as much as possible.**

CHAPTER 13

THE FIRST TIME YOUR CHILD USES THE POTTY

When your child urinates or has a bowel movement in the potty for the first time you need to be ready to explain what has occurred and reward it accordingly. Children can act quite peculiar when they use the potty for the first time. Mixed emotions can be expressed. Some children may be very surprised and even alarmed at what has happened. It is not uncommon for children to be saddened by having "lost control" or having something strange come out of their body. In these cases, a parent will need to explain that what took place is normal and good. Young children who do not understand what took place will do better if you avoid overemphasizing the details of the event. If your child is confused, praise the event and explain it further the next time. As long as you can alleviate any concerns or fears your child may experience, you have done your job. Your goal is to make sure your child is not discouraged from trying to use the potty again in the near future.

Children need to be praised and praised and praised the first several times they use the potty. Try to be extreme with your expressions so your child has a clear understanding of how happy you are he used the potty. Dance, hug, kiss, sing a song, and do whatever it takes to entertain your child. Be loud and tell other family members to come and see what happened so everyone can express their excitement. Even call someone on the phone, such as a family friend or relative, and have your child listen or tell the story about how she used the potty. Children love everyone's praise and

attention. Provide a party-like environment. Your child will most likely think this is funny and want to try again to get a similar sense of gratification. Showing your emotions will also distract them from any confusing or unpleasant ideas they may have about going to the potty for the first time. Be careful to not look disappointed if he tries next time and is unable to go on the potty. Reward good actions on the potty and compliment attempts even if results are not obtained. Children usually desire to please their parents; if they try to use the potty and are unsuccessful, they will sense your disappointment if you express it. Simply tell him he did a good job trying and he will try it later. At our house, each child was very happy to have everyone's attention when they went on the potty for the first several times. It was a fun and exciting time for everyone.

CHAPTER 14

REFUSING TO POOP IN THE POTTY

Children tend to control their bowel movements prior to controlling their urine. At least that is what we think. It is very hard to determine if a young toddler intentionally wets or has a bowel movement. Since children tend to obviously hide or grunt to have a bowel movement, we are aware when they are in control of this process. It is believed that children develop control of their bowel movements at a young age. However, just because a child does not hide or posture when urinating does not mean she does not exercise control of her bladder. Since urination is relatively effortless, toddlers may urinate often without exhibiting obvious signs of control.

Since having a bowel movement requires a slightly different process, some children may show earlier signs of wanting to go poop in the potty. Having a bowel movement usually requires some straining, and children who are toilet training tend to strain when trying to use the potty. Some children may even be "potty trained" for their bowel movements well before they will urinate in the potty. Just the opposite may also occur. Some children will pee in the potty, but insist on having a diaper on while having a bowel movement. It can be extremely frustrating when a child refuses to use the potty to have a bowel movement. When this occurs, parents commonly are unsure how to proceed since the child clearly knows what she is doing and has complete control of her bowel movements. To add to the frustration, most of these children will ask to have their diaper changed or removed after they have pooped.

Training your child to use the toilet for bowel movements is not much different than training them to urinate in the toilet. First, your child must show signs of being "ready" to train. The signs your child will display for having control and interest in being trained for having a bowel movement are no different than the signs that they are ready to be potty trained for urine. If you proceed with general potty training (whichever technique you choose) and your child is only willing to pee in the potty, then talk to him and see if you can understand his reasoning. Sometimes the simplest concerns or misconceptions can be relieved, and your child will start to poop in the potty. However, it is not usually this easy. If your child is unable or refuses to discuss his issues, you may be forced to decide

whether you will permit him to use the diaper or pull-up for having a bowel movement. If you are patient, he will eventually have a bowel movement in the toilet and become completely potty trained.

If you want to take a more active role, then you may need to spend more time explaining and exhibiting the bowel movement process. Consider having him observe you having a bowel movement. Explain everything you are doing in very simple terms. Tell him that he will need to sit on the potty with legs separated and lean forward. This flexion at the hips improves sphincter relaxation. He can even see the poop go in the potty if he likes. Tell him that water may splash, but it is normal and not scary. Have your child watch you wipe and ask him to flush your BM "bye bye". If your child has a bowel movement in his diaper do not scold him, but instead tell him next time he will sit on the potty to poop. Have him help with shaking the poop out of the diaper and into the toilet. Again ask him to flush and sit on the potty to wipe his bottom.

If he continues to refuse to poop into the potty, have him sit on the potty with his diaper on and allow him to proceed with having a bowel movement. Praise him for at least sitting on the toilet for having a bowel movement. Show him to watch as you shake or scrape the poop into the potty and then flush it away. Tell him it may splash or make a noise. Gradually have him assist more with removing the diaper and emptying it into the toilet. If he still insists on wearing a diaper you may want to consider cutting out the bottom portion of the diaper so the bowel movement will fall through the diaper and into the potty. It may be helpful to gradually remove or replace the diaper if your child has sensory integration issues. Some children can develop a strong sense of security with the feel of wearing a diaper.

It is very common for children who refuse to poop in the potty to develop constipation. Even if constipation is not a problem, a simple and safe tip to get your child to use the potty for bowel movements is to cause your child to have more frequent and soft stools. Not only are large and hard stools more frightening for a child, but frequent and soft stools are harder to hold while urinating on the potty. Your goal is to make sure the stools are very soft (the consistency of rotten bananas) and occur often so your child is less successful at holding. Timing is also important. The body has a normal gastrocolic reflex, which encourages us to have a BM after meals. If you have your child sit on the toilet 10-15 minutes after each meal you are

more likely to have success at having her poop in the potty. This is even more likely if the poops are soft, frequent, and easily passed.

Do not forget that urinating and having a bowel movement are closely related. Do not fall into the trap of only focusing on one problem. Simply having your child sit (including the boys) to pee will make him become more comfortable on the potty. The more he sits to pee the more comfortable he will be and the more chances you will have at getting him to have a bowel movement in the potty. If you implement a bowel program that causes frequent and soft poops, then bowel training is even more likely to happen. Remember, if you have successfully trained your child to use the potty for either pee or poop, use the mastered skill to your complete advantage, and have her go to the potty often. You may need to be structured, firm, and consistent with your requests to use the potty. By doing so, there is better likelihood of your child becoming both bladder and bowel trained.

If your child resists and convinces you to allow her to use the diaper or pull-up for having a bowel movement, then she will delay the process of going in the toilet. "Tough love" may need to be tried, especially if all else has failed. One example of tough love is to try "poop jail". This is most effective when you know your child needs to have a bowel movement. Poop jails involves having your child stay in a room without many toys or distractions (much like timeout), and instruct her that she can come out when she decides to poop in the potty. Advocates state this may be preferred to forcing your child to sit on the potty and poop on command. Simply placing your child on the potty can work and it is probable that she will eventually go. Once she realizes she can go poop on the potty and not be alarmed, then she will be more willing to do it again. If you show significant praise towards your child and reward her for having a bowel movement on the potty, this will also encourage her to use the toilet for both urine and stool.

Along with the use of stool softeners, you can also try to loosen his stools with the addition of extra fiber to their diet. However, in most cases, juices, fruits, and vegetables may not be enough to significantly loosen the stools to result in the 2-3 bowel movements per day that you are trying to achieve. You can also try fiber supplements to see if your child's stools will change. In most difficult cases, you may need to try a laxative to cause frequent and soft stools that are needed to cause your child to poop

when they pee. Before trying these tactics, consult your pediatrician or family physician to see if she agrees with this approach.

Your child's doctor may have special concerns or preferences in regards to your child taking a laxative. If you choose to try a laxative, make sure it only causes your child to have 2-3 bowel movements a day. The laxative may need to be used for several days or weeks until you get your child to use the potty on a regular basis. Using long-term laxatives or doses that cause significant diarrhea can be harmful unless monitored by your child's doctor. The most commonly used laxatives include milk of magnesia, mineral oil, Senokot®, lactulose, and Miralax™. Almost any laxative can be effective. I have recommended this technique to many of my own patients and have seen excellent results.

Many books on potty training describe how constipation can cause large and hard stools that push against the bladder and cause spasms or prevent the bladder from emptying. This has never been proven, and although this explanation is plausible, in my opinion it is unlikely to be the case. Certainly, if the stools are huge then a mass-effect can occur and cause irritation to the bladder. I believe the most obvious explanation for the association of constipation and bladder symptoms rests with the child's unwillingness to use the restroom often, not because a large stool pushes against and irritates the bladder. Think about it, if a child does not want to use the restroom to poop, then she will develop constipation. That same child probably does not want to use the restroom to urinate. Holding both urine and stool is the result, which then causes bladder spasms or the inability to relax and empty when she does go. Furthermore, as the

constipation worsens it becomes more difficult or even painful to have a bowel movement, which further discourages her from wanting to go potty to urinate.

CHAPTER 15

TEACHING YOUR CHILD GOOD POTTY HYGIENE

Potty training provides an excellent opportunity to teach your child good hygiene. Although young children may not understand the importance of keeping their hands and privates clean, they can be trained to wash their hands, wipe properly, and flush the toilet or empty the potty chair. As good potty hygiene becomes a habit at home, your child will carry this positive behavior into other environments.

Good hygiene is especially important when using public bathrooms to avoid contracting or spreading diseases. Once your child gets into a routine of washing his hands he will probably do it the rest of his life. During potty training, children should be taught good hand washing skills. They should wash their hands after each use of the potty. Even if your child was unsuccessful at going, you should encourage him to wash his hands so he develops this habit. Whether they use soap and water or antibacterial gel is up to the parents. Children should begin to understand that urine and stool can be 'dirty' (they contain viruses and bacteria) and it is important to wash their hands after using the restroom. You may need to be careful, because if too much emphasis is placed on the 'dirtiness' of going to the restroom, then he may develop an avoidance of going. Too much discussion may instill a fear of getting dirty or cause your child to avoid going in order to avoid washing his hands. As with most lessons of life, you will need to maintain a balance of educating your child without instilling fear in him.

Other lessons should also be instructed to children while they potty train. Wiping is something your child should quickly realize is routine when using the potty. Even if your child is not able to wipe satisfactorily, they should be given the opportunity to try. Without guidance children will avoid wiping, even when they have a bowel movement. Girls should wipe front to back when they urinate. Parents commonly get frustrated when trying to get their girls to wipe correctly. Do not get too upset if it takes time for your child to learn the right technique. Despite what you hear, incorrect wiping by girls probably does not cause infections in most girls. It is preferable for girls to wipe correctly, but with instruction they will eventually learn. Children should also be taught not to wipe excessively, because this may lead to skin irritations that can become problematic.

Therefore, you should be prepared to assist your child for months or years to teach good hygiene and wiping techniques to avoid future problems.

These simple lessons will teach your child a routine that should be practiced each time she uses the potty. There is no better time to begin these instructions than at the beginning of potty training. If you start early in the training process your child will become more comfortable with the whole process and less confused than if you implement it later. However, too much emphasis or attention to hygiene detail can derail your attempts at training. Try to keep your instructions simple and without too much detail. Teach just the basics. If your child is overwhelmed by too many rules or instructions, you may want to wait until she exhibits progress and consistent potty results before trying to instruct him on hygiene habits. By taking the time necessary to teach your child to follow these basic instructions, you are instilling good potty hygiene habits that will help prevent illness and promote overall good health.

CHAPTER 16

SETBACKS AND WHY THEY HAPPEN

- **Accidents:** Children are easily distracted and can be "thrown off" by a change in their everyday routine. Children will often hold their urine or stool as long as possible to avoid interrupting their play. They are commonly unable to prioritize their activities and do not understand that holding too long may result in accidents. When accidents happen, it is best to show regret, help the child to see what they should have done, and have them help clean up the mess. They should not be punished, but instead told to go to the potty more often and instructed to take their time on the potty. If the accidents are getting worse, then you will need to take charge of their potty schedule until they are 'back on track.' This may require telling your child to use the bathroom instead of asking if he needs to go.

- **Belly Pains (bladder spasms and constipation):** If children hold their urine and/or stool for whatever reason (usually to play or watch TV), they can cause themselves to have vague abdominal (belly) pains. Children are not usually wise enough to understand that their holding is causing them discomfort. If your child is having these pains, then monitor their stools and their potty habits closely. If your child has large or hard stools or needs to go in a hurry, then she is holding. If she is holding, make her go more often and have her take her time. Simply going potty will usually resolve most or all of these pains. A child that develops constipation (large or hard stools) may need to be treated with diet changes or a mild laxative (see your doctor) while you redirect her potty habits.

- **Urinary Tract Infections (UTI's):** *The most common time a young child gets a urinary tract infection (bladder or kidney) is around the time of potty training.* Urinary tract infections occur most commonly between 18 months - 4 years of age. Girls are more likely to get an infection because their anatomy more easily allows bacteria from their rectum to enter the bladder. The confusion associated with potty training can cause holding and incomplete emptying of the urine and stool. Diapers that are still

being used during the potty training process can harbor bacteria. Rashes that are associated with diapers and pull-ups can also cause a child to hold their urine and stool. All of these factors may contribute to your child getting an infection. Even children who are potty trained can hold their urine or stool, which leads to infections, without the parents being aware. Therefore, it is always a good idea to have your child go often and take his time. Avoiding a urinary tract infection may save your child from unnecessary medical testing and treatment. Your child's doctor will need to address the infection if it occurs.

- **Transitions and Disruptions:** Changes in your child's daily routine may cause problems with potty training. Such changes may include a new baby in the home, moving to a new house, going to a new school, a recent divorce, etc. If this is the case, it might be best to hold off on potty training until your child feels more comfortable with his surroundings and social situation.

- **Diaper Rashes/Irritations:** Irritation to genital or anal areas may cause your child to hold or resist potty training. Sometimes diaper rashes or irritations will cause your child to remove the diaper and even try to potty train. Regardless of the outcome, you will need to be aware that painful bottoms can cause difficulties with a child wanting to pee or poop. Treating the rash or seeking medical treatment can easily solve these problems.

- **Moving too fast:** Your child may not be ready for potty training, or you, as the parent, may not be ready to train your child. If either of these is the case, potty training should be delayed in order to avoid frustrations and other problems. Simply putting the potty training on hold for a couple of weeks or months may be the best thing for everyone.

- **Public Restrooms:** It is common for children to not want to go potty in unfamiliar places. This usually stems from fears that are instilled by parents or from caregivers. Parents should avoid portraying public restrooms as being different than the potty at home. They are not scarier or dirtier—at least should not be portrayed so initially during the training process. Try to keep the process uniform and not any different than at home. Make sure

schoolteachers, grandparents, and care givers use the same technique that is used at home. For example, if you normally accompany your child to the potty, then ask them to do the same. Make sure your child has exposure to as many different potties as possible. Encourage others to escort your child to the bathroom so she does not get reliant on your presence. The more your child will use a public restroom in your presence, the more she will use it at school or when you are not around. Avoid allowing diapers when away from your home, as this can lead to confusing the child, and empower others to enforce your rules when your child is away from home so consistency is maintained.

CHAPTER 17

THE RESISTANT CHILD

Many children are simply difficult to toilet train. You should not feel like a failure if your training is not successful. Accidents and holding are sometimes caused by a power struggle between parent and child. If you think this is the case, you may want to back off on the potty training, and figure out why your child is resisting the process. Other possible causes of resistance might include anxiety/fear about the potty, confusion about what he is supposed to do, independence/autonomy issues, too much pressure to perform, and inappropriate toilet training techniques. Once these issues have been resolved, your child is less likely to be resistant and you can proceed with training if you feel it is appropriate.

Many times it is impossible to determine the reason your child will not train. The parents have the right to pursue any technique or style they choose, and as long as a loving environment is maintained, then you can tailor any approach to your situation. You can even choose to retreat, stop the process, and consider retrying at some time in the future. You can also elect to try a completely different approach, which usually involves a more intensive and stricter style. Another approach, which may seem somewhat peculiar, is to recruit a friend, neighbor, or family member to train your child. This allows a more independent person to be responsible for the training and may help to eliminate some of the control issues encountered between parent and child.

Your child will eventually be trained. If having difficulties training your child, take a break from the process and refrain pressuring your child to potty train. This will relieve the stress that may have developed between you and your child. If you wait several months and try again, your results may be vastly different. In the meantime, your child may become more mature and learn some indirect potty lessons. During this time, you may be able to instill some more structured rules and discipline that enable your child to view you as a well-respected (and loved) boss. Your communication style with your child may improve so he realizes to listen and trust your advice about issues that are non-potty related. So when the time comes to retry the toilet training, he may try harder and be more trusting of your directions. If your child

continues to exercise power struggles even after the initial break, then retrying a few months later may only bring back a more difficult situation. In this case, sticking with the program may be best.

Parents who are faced with difficulty training a resistant child most commonly do not take a gradual, consistent, and broad-based approach to training. In other words, they usually start with rewards, a special potty, and try to get their child interested in sitting on the potty. Although this works for many children, others require more time with instruction, explanation, and consistent training. If the instruction is directed in simple and more absolute terms, then success is more likely. Explaining what will take place and exhibiting these steps to these children will also be helpful. Finally, training that involves intensive and undistracted instruction will make the child understand that the parent is motivated to follow the process through until success is achieved. Showing the child that the diapers are thrown away and the potty will be the focus for the day will help immensely. Following many of the other suggestions in this book will also help. These include:

1) Being prepared to spend several hours or days without interruption,

2) Making sure emphasis is placed on **both** pee and poop,

3) Starting a bowel program—like a low dose laxative—that causes several soft poops a day,

4) Making sure the child sits comfortably, relaxed, and for several minutes on the potty,

5) Providing rewards that are desired by the child, but controlled by the parents, and

6) Consistency—making sure your child hears instruction from one source so manipulation and confusion are avoided.

As long as your child realizes the process is non-negotiable, but does not fear punishment, then it will be in her best interest to try and succeed. This may seem excessively forceful by some; therefore, this approach should only be implemented by those who feel comfortable with setting strict rules. If your frustration level is high, then you need to increase your

actions (like those stated above) or decrease your frustration level and not pursue this more aggressive approach.

If parents do not feel they are capable of getting their child trained, or if they simply fear doing it incorrectly, then they can consider asking a trusted and experienced adult to help. This is somewhat awkward, but it can be a very rewarding and effective way to train your child. Many resistant children are more likely to listen to another adult than to their own parents. Some parents do not have the personality or schedule that is required to train a difficult or confused child. If you know of an adult you trust who has experience toilet training children, then you can consider asking him to train your child. Again, as long as it is a loving and non-abusive environment it may be the best way to teach your child. Grandparents and friends are almost always willing to provide advice, consider taking them up on it and have them guide or control the process.

Family and child counseling should be considered if the potty training process seems to have hit a brick wall. Underlying issues may be revealed, like processing or sensory integration abnormalities, which may explain why you have not made any progress. Parenting styles or marriage discord may be giving your child mixed signals or distracting him from wanting to train. An outside perspective may be refreshing and enlightening. If there are differing opinions between parents or among family members on how to approach your child's problem, then an unbiased observer may be very helpful. When consulting a professional, keep in mind that psychologists and psychiatrists usually avoid more parent-directed approaches to potty training and tend to support approaches that allow the child to determine when she is ready to train. If this is not the approach you wish to take, you may consider consulting a different specialist.

CHAPTER 18

REWARD SYSTEMS

Children always respond to praise. If you want your child to perform a particular task, give them a hug, kiss, or word of encouragement, and she will likely do what you ask. Potty training can be greatly improved if your child is rewarded for using the potty. However, be cautious when rewarding a young child when they use the potty because she may not yet be ready or able to go on command. Therefore, she may become frustrated when trying to potty but is unable. If she is unable to use the potty and does not receive a reward, then she might feel disappointed or punished for something that is beyond her control. As a parent, you should approach the rewards for using the potty carefully. Rewards can be an extremely helpful tool, but it should be used when your child is "ready" to potty train.

If you are going to reward your child, you must explain that you are never mad or upset if they have an accident. Toddlers should not feel ashamed or embarrassed if they are not progressing as fast as their parents' desire. Rewards should be explained as being an extra benefit for using the potty, and there should be no consequences for refusing to go potty. The rewards should not be expensive or extravagant because this will cause the child to be especially disappointed if he does not go. The rewards should be small and simple--extra hugs, kisses, and praise is good for starters. Giving a

child extra time to do his favorite activities is another good idea. Children that use the potty may get "extra" benefits, but a child who does not should still be given compliments for simply trying.

The most common reward system is a calendar and stickers. The calendar is excellent because it allows you and your child to monitor trends and progress. Placing stickers on the calendar is usually a positive sign for achieving a goal of using the potty. Stars, animals, or complimentary words are excellent sticker choices.

59

Ideally the stickers should be placed on the day of the month or week when the child uses the potty. This should be a private time between you and your child so you can talk positively about what happened. If your child did not go, you should explain that he can try again. You can choose your own reward system, but make sure you do not "bribe" your child to become dry. It is probably not a good idea to reward a child with candy or toys, unless a special circumstance arises. We tried using small chocolates when training our first child. They worked the first few times, but they were a total failure in the long term. Our child became more focused on getting the prize than doing what was being taught. If the rewards are too exciting or too fancy, then your child may try too hard and become frustrated by his lack of progress.

When children are not interested in obtaining the typical rewards, consider trying exciting rewards that are kept under the parents' control. These are referred to as temporary rewards. If the reward is something unique or exciting, like playing with their favorite toy, watching a movie, or playing a special game, the child is more likely to respond. The children are allowed access to these items more easily, but for shorter times when they first respond favorably. The parent then keeps control of the item and does not allow access unless they respond more favorably the next time. In other words, they receive increased access to the item when they perform, but not total possession. Children are no different than adults; we all covet what we cannot have.

CHAPTER 19

BEDWETTING

Getting your child to be dry at night may not come easily. It is very normal for children to wet at night immediately after becoming potty trained. These young children tend to not completely empty their bladder each time they go potty during the day; therefore, they are not usually empty when they go to sleep. Children are also deep sleepers, and they do not yet realize the sensation of a full bladder while they are sleeping. Some children are fortunate to be dry at night early in the potty training process. They may even be dry at night before they are trained during the day. Children, who are lighter sleepers, have larger bladders, and practice good daytime potty habits are more likely to be dry at night. Unfortunately, parents cannot change their child's sleep patterns and they cannot make their child's bladder become larger. Making sure your child has good potty habits during the day will, however, help her chances of becoming dry at night. General guidelines for establishing good daytime potty habits in your child include:

- Making sure your child goes potty often-at least every 2 hours during the day
- Do not ask your child if they need to go, simply tell them to go
- Have your child be comfortable on the potty—tell her to relax and take her time
- Your child should sit on the potty (even the boys) and relax for 3-5 minutes
- If your child does a "pit stop," nicely send him back
- Do not have your child push, strain, or grunt to pee
- Avoid stimulants (caffeine drinks, chocolates, sugar-rich foods)
- Make sure your child has frequent bowel movements that are small and soft (goal=2 poops a day)

Most physicians and child experts do not consider bedwetting a problem until the child becomes at least five years of age. Treatment for children who wet at night is, therefore, not usually pursued until the child is older. As a parent, you can pursue treatment whenever you perceive the bedwetting to be a problem. Since bedwetting will resolve on its own and without any treatment, you should cautiously pursue treatment in children

younger than five. Medications that are used to stop bedwetting, for example, may be too extreme of a treatment in a younger child. On the other hand, restructuring your child's daytime potty habits or trying a bed alarm is probably not too extreme to try even at a young age. As a parent, you will need to address your approach and concerns according to your child's age and problems. Despite what others may imply, your child's bedwetting most likely does not mean your method of potty training was wrong or done incorrectly. Do not feel guilty about your child being a bedwetter. If your child is older and still wets, then you should consult your child's physician or get more in-depth information about the causes and treatment options for bedwetting.

Some simple things you can do to help your young child become dry at night include:

- During early toilet training, continue using diapers at night, but praise your child if they wake up dry.
- Let your child wear panties to bed after periods of continued dryness.
- Restrict fluid intake before bedtime.
- Make it a routine of using the toilet before getting into bed.
- Make sure the way to the bathroom is lit and easy for your child to find in the middle of the night.
- Work hard to ensure your young child develops excellent potty habits after potty training.

CHAPTER 20

KEEPING YOUR CHILD POTTY TRAINED

Unfortunately, your job does not end once your child becomes potty trained. Most potty training instruction does not educate parents on the importance of establishing good potty habits after the initial potty training phase is complete. This is absolutely crucial in order for your child to maintain dryness and not develop many of the other problems that are associated with abnormal potty habits. Just because a child learns to use the potty to urinate and have a bowel movement does not mean he completely understands these bodily functions. Children who recently have potty trained are typically very young and do not realize the importance of going often and relaxing on the potty in order to empty the bladder and bowel completely.

Instead, they tend to hold, squat, wiggle, and dance in order to avoid going to the potty as long as possible. If they wait too long, they may have an accident because they cannot get to the restroom quickly enough. They would rather play, watch TV, and do just about anything than use the potty. When they do go, they usually go in a hurry and do not completely empty. These "pit stops" can result in having to go potty often because these children did not empty the bladder completely the first time. A bladder that does not empty can also result in urinary tract infections and other problems. Children who hold their urine usually also hold their stool. Similar pelvic muscles

(sphincters) are tightened when trying to hold urine or stool. This holding of stool will eventually result in constipation and abdominal pain. In short, newly potty-trained children will need to be coached and monitored to avoid the problems associated with abnormal potty habits. Common problems that can be avoided by establishing good daytime potty habits include:

•Urine frequency •Urinary tract infections
•Urinary hesitancy •Abdominal (belly) pain
•Urinary incontinence (accidents) •Constipation
•Urgency •Bowel accidents (encopresis)

I strongly recommend a program that establishes good potty habits in all children but especially in those who exhibit confusion or problems after potty training.

BASIC PROGRAM

#1 Children must use the bathroom the moment they wake up and at least every two hours during the day until going to bed. Going more often is fine: do not discourage using the bathroom. Avoid using statements like "wait till we get home" or "try to hold it longer." This advice is confusing for parents with children who already go often, but even these children will have times when they experiment with holding and do not go for longer periods of time. Do not ask your child if they need to go potty or if they can go. Just simply say it is time to go potty. With time, they will understand that this request is non-negotiable. Give them a hug, kiss, and tell them you love them, but tell them it is time to go potty.

#2 Children should be told to relax and take their time in the restroom. They must not strain, push, or be in a hurry. Normal urination does not work with straining. Do not tell her to "push and get all of the pee pee out." If she is straining or trying too hard, tell her to stop and relax. Close the bathroom door and tell her to sit deep into the potty with her legs apart. Closing her eyes and taking deep breaths may be helpful (I call this "potty yoga"). Do not send her with a book, game, or toy. This will only distract her from understanding the subtle sensations of normal emptying of her bladder and bowel. Pit stops are not allowed and she should stay on the potty for 3 minutes (she may think it is 3 hours but it is just 3 minutes). If she comes out too soon, send her back. Just because she thinks she is

done, she probably has not completely emptied and should remain on the potty a little longer.

#3 Children with difficult potty habits should avoid stimulants that cause them to be hyperactive and drinks and foods that are irritating to the bladder. This becomes especially important when a child has been diagnosed with ADD, ADHD, or is classic anal-retentive. There are many items on this list but the big offenders are caffeine drinks, chocolate, and sugar/carbonation drinks.

#4 A bowel program is essential. Painful or difficult poops and poops that take too long to come out will discourage a child from using the potty. Since the focus of our treatment is to encourage frequent bathroom visits, then we do not want to be sabotaged by any poop problems. Remember, even if a child does not have obvious constipation they will need to have frequent bowel movements in order to pee better. There are no medications or procedures that will make a child pee better, but if he has frequent bowel movements (goal=2 poops a day), then he will have to sit, take his time, and usually ends up peeing well when he poops.

We can safely manipulate the bowel movements with diets and mild laxatives. Fiber, fruits, vegetables, and increasing fluid intake are ideal but good luck getting a child to take as much of these that is required to get the desired effect. Fiber is becoming easier to give since there now wafers, cookies, and flavored drinks that are available at most pharmacies and health stores. Making the stool softer and having a bowel movement a day is not usually sufficient to improve potty habits. Therefore, laxatives should be considered since they are not harmful if given in low enough doses that result in two poops a day for several months. Diarrhea and weight loss are signs that too much laxative is being used. If these happen, just cut the dose back, but do not discontinue the use of the laxative. I usually tell the parents to start low (example ½-1 tablespoon a day of milk of magnesia) and slowly increase until 2 poops a day is achieved. For older or larger children, several tablespoons a day may be required.

It will take a few weeks to determine the dose for any given child taking any laxative. Parents should plan on their child taking the laxative for several weeks or months. There is no preferred laxative. Some are easier to give and taste better. A few do require a prescription but most do not. Laxatives come in powders, liquids, pills, and chewables. Common

examples include Miralax™, Senokot®, lactulose, mineral oil, and milk of magnesia.

PROGRAM HELPERS

The basic program outlined above is usually sufficient to correct most potty problems in children. Sometimes additional help is needed from devices and products that reinforce the need to make sure your child is following the program and achieving success. Listed below are some of the more common items parents may want to also consider when attempting to improve their child's potty habits.

Reward systems are helpful, especially for the younger children. As stated previously, praise from everyone is important. The child needs to know that good potty behavior is rewarded with praise and satisfaction. Stickers, small items, toys, and even candy are commonly used. I am not a big fan of toys and candy since they become bribes instead of rewards for good behavior. Calendars that allow several stickers to be displayed work very well and they promote consistent and daily feedback. Rewards should be simple and achievable. The rewards should also be directly related to good potty behavior and not linked to other issues or problems.

Bathroom timers can give children visual or audible feedback on the amount of time they should stay in the restroom. Remember children like to take pit stops and not take their time when using the restroom. Timers that have the children stay on the potty for 3 minutes can be very valuable, since they will learn to take their time without the parents' direct supervision.

Watch reminders are tools to remind children during the day, when the parents are not necessarily around or paying attention, to go to the bathroom often. Watches with the auto-reset alarm feature are best suited for this purpose since the reminder does not need to be reprogrammed each time. Depending on a child's schedule, these watches should be set to alarm or vibrate at least every 2 hours. Younger children may not mind an alarm and teachers and parents who hear it can also instruct the child to go potty. Older children may be embarrassed by an alarm and desire a watch that vibrates, but vibrating watches are usually more expensive and larger in size than watches that sound an alarm. Either watch encourages the child remain on a consistent daytime potty routine by requiring that the child respond to the reminder.

Urine collection devices can be obtained from a medical supply company or a physician. These open containers fit into the commode and collect the urine. A child and parent can then measure and see how much urine is produced with each trip to the potty. If a small amount of urine is present then the child is probably not completely emptying. By monitoring the amount of urine eliminated, the parent and child team can work together to increase the amount of pee per trip to the potty. These collection devices provide positive visual feedback when the child is improving while allowing the parent to monitor the progress.

Voiding and bowel diaries are useful when the parents are trying to monitor how often a child is peeing and pooping. Many times the parents are not completely aware of what their child is doing while at school and away from home. By keeping a diary, parents can see if their child tends to have more problems during specific times of the day, at particular places, or during certain activities. Diaries are only helpful if they are accurate and kept for several days. Comments about the amount of urine and the consistency of stool should also be included. Simple homemade charts suffice but specially designed diaries are also available.

CHAPTER 21

CHILDREN WITH SPECIAL NEEDS

Potty training a child with a special need can be one of the most frustrating experiences or one of the most rewarding milestones for any parent and child. Children with special needs will require more attention, direction, assistance, or encouragement than other children. Fortunately, potty training your child can be accomplished using many of the same techniques previously mentioned in the book. As with any technique, the process must be individualized to your child's personality and mental and physical capabilities. You know your child best, and you are the expert when it comes to individualizing the potty training process to your child. There may be approaches or techniques that you have used in teaching your child other routine daily functions that can be implemented when attempting toilet training. Remember, no one specific technique will work for every child, and this is especially true with children with special needs.

Depending on your child and his special need, you may need to be creative and diligent in order to accommodate your child physically, neurologically, or emotionally. For instance, a child with autism or developmental delay may require visual stimulation and simple, concrete directions. This may consist of pictures of the potty and task oriented simplistic, step-by-step instruction. You will need to be prepared to be basic and set realistic goals that will eventually lead to teaching your child to use the potty over a period of time. In other words, your goal may be simply to get your child into the restroom before even attempting to get your child to sit on the potty. A child with a physical need may require extra support or assistance to the restroom, when getting on and off the potty, and returning to his normal activities. Potty seats with extra padding, supports, or that are raised may be needed. Your goal will be to ensure your child is comfortable while sitting on the potty, and in turn, he will relax and be more successful when emptying the bladder and bowel. Remember, children that are tense or uncomfortable on a toilet are much less likely to have successful results at eliminating urine and stool.

Children with physical disabilities (as opposed to mental) may be discouraged by their physical limitations, and in turn, be uninterested in becoming toilet trained. Parents and caregivers will need to accommodate the child's disability so that the toilet training process is as comfortable

and as effortless of an experience for her as possible. Depending on her disability, suggestions for assisting your child with a physical limitation include:

- Assist with ambulating to the potty.
- Make available portable toilets or multiple toilets within close proximity to your child.
- Provide braces or side rails for extra support (potty throne).
- Offer a bell or alarm so that your child can communicate the need to go potty.
- Assist child when getting on and off potty.
- Provide a special toilet seat with extra cushion or features that meets your child's needs.
- Allow your child to sit backwards on the toilet and lean against the toilet for extra stabilization. Your child can also face forward and lean backwards against the toilet.
- Wiping and keeping your child clean will encourage your child to want to stay out of diapers. Children usually like to be clean and odorless.
- Once your child is able to toilet normally with assistance, then avoid using diapers so that regression does not occur.
- Visually impaired children should be introduced to sounds and objects that are unique to the bathroom.
- All of the above should be made available at schools, other care providers, or anytime the child leaves the home.

Toilet training a child with a mental disability can be a challenging task for any parent. Processing the concept of toilet training and then integrating the process into the child's specific disability will probably be the biggest obstacle you will need to overcome. Depending on your child's mental capabilities, this will probably be a more tedious and slower process than training a child without special needs. Associations with objects, pictures, or sounds will help condition your child to develop each step of the potty training process. The more profound the mental disability, the more simplistic, gradual, and controlled approach will be necessary. Suggestions for potty training a child with a mental disability include:

- Present clear, concrete, and basic instructions of each step that you are trying to achieve.

- Acclimate your child to the various objects and sounds that are unique to the bathroom. A mirror or a flushing toilet can be extremely distracting to some children.
- Provide simple pictures relating to bathroom tasks and make them a routine. Consider taping them to the bathroom wall or near the bathroom so your child understands what is going to take place. You will need to be prepared to show a picture or object or make a gesture to get your child to perform each and every individual task. For instance, a picture of a toilet instructs the child to sit on the potty. A picture of a sink instructs the child to wash his hands. Remember to send these pictures or objects with your child to school or any time the child is away from home. Instruct teachers and caregivers on the use of them. **Simplicity and consistency are crucial!**
- If your child shows fear or uneasiness related to using the potty, consider providing soft, relaxing music or allowing your child to bring a comfort toy or object with them while in the bathroom.
- If you decide to reward your child, show him either the actual reward or a picture of the reward. Don't simply tell him about the reward.
- Children with sensory integration dysfunction may require gradual transitioning from diapers to underwear. Tips include slowly cutting away the diaper or allowing them to wear multiple tightly-fit undergarments. Also consider placing the undergarments under or over the diaper.
- Even if your child seems to be progressing quickly at toilet training, avoid the temptation to introduce too many stimuli (like flushing or water splashing on his bottom) that might result in a significant setback.
- When trying to determine if your child with developmental delay is "ready" for training, consider using the child's mental age rather than physical age. Consider consulting a specialist if you are unsure of your child's developmental level.
- In general, boys with any special need, mental or physical, should initially sit down while using the potty.
- Don't show frustration if your child has difficulty comprehending the potty training steps.

When potty training children with special needs (both physical and mental), a parent-directed approach will need to be considered, in that the parent is typically the one to initiate and encourage the process. Children with disabilities are less likely to exhibit the typical signs of toilet training readiness, and it will be the parent's responsibility to determine his child's general abilities and how these can be directed toward potty training. Your child may be reluctant to begin the process because of lack of confidence, fear of failure, or uncertainty. Parents should be prepared to motivate your child, accommodate her needs, remain consistent throughout the process, and build the child's confidence no matter how many unsuccessful attempts she may have. No matter what special need your child has, she will need encouragement and praise throughout the entire potty training process, since it may be one of the most challenging processes of her life. Positive encouragement should be given not just for being successful on the potty, but also for simply trying. Your child should never be punished for unsuccessful potty attempts. Every child, particularly a child with special needs, desires parental approval.

If you begin to feel frustration while potty training your child, you may consider backing off and trying the process at a later time. Toilet training should be a rewarding time for both you and your child, so remember, no matter how long the process takes or how many unsuccessful attempts your child has, continue to praise, love, hug, and kiss her and let her know how proud you are of her. You have a difficult task ahead of you, not impossible, just difficult. So put on your running shoes, build up your team, and be prepared to step up to the challenge.

COMMONLY USED MEDICAL WORDS

Anal Retentive: A personality style described by the famous neurologist Sigmund Freud. This personality style usually is associated with extremes of personalities. Typically these individuals are very organized, structured and controlling. People with this personality may be super-achievers or referred to as having a type A personality. It may be a temporary state but usually these people are intense, emotional and at times uptight. I am not throwing stones, since I tend to be commonly placed in this classification. For the purposes of this book, children that are anal retentive tend to have tight pelvic muscles and tend to hold their urine and stool for longer periods of time because their personality causes them to be focused and interested on other issues. They typically tend to have abnormal potty habits.

Anal Fissures: Cracks or tears in the anus. Anal fissures commonly occur with large or hard bowel movements. Anal fissures are common in children with constipation and they can be irritating, painful, and itchy.

Anus: The external part of the body where stool comes out.

Bladder: The body organ that stores and empties urine. It is a muscular organ that stores urine under low pressure. The bladder's muscle contracts when it is instructed by the brain to empty. The size of the bladder is usually proportional to a child's body size and age. Some children are born with larger bladders than others, but a general rule is bladder size (ounces)= age + 2.

Bladder Spasms: When the bladder has a sudden urge to empty. If one has a neurological problem or an infection there may be significant bladder contractions or spasms. In children with abnormal potty habits the bladder is not able to fill and completely empty at normal intervals. In these children the bladder muscle tends to get thicker and stronger because it attempts to empty against an abnormally tight sphincter. At times the bladder will suddenly contract and try to empty, causing a spasm, without any other underlying abnormality. Bladder spasms result in stomach cramps usually below the belly button, pelvic pain or leakage of urine (incontinence).

Constipation: A loose definition would include any child with abnormally large, hard or painful bowel movements. In a child with abnormal potty habits, constipation usually results from holding stool for long periods of time. Diet and fluid intake can also cause constipation. Well-rounded diets that include normal fluid and fiber intake could prevent constipation from occurring, as long as a person has frequent bowel movements. Most

children have an average of one bowel movement per day and anything less than this can be loosely described as constipation. Constipation can result in belly pain, cramping, painful bowel movements and even bowel accidents (encopresis). Anal tears, bleeding, and itching can also result from constipation. Fecal staining of the undergarments also hints that a child may have significant constipation.

Cystitis: An infection or inflammation of the bladder. The infections are usually bacterial (example E.Coli) and can result in significant urinary symptoms that include frequency, burning on urination, leakage, pelvic pain, and blood in the urine. Low-grade fevers may be associated with cystitis but are usually not greater than 101°.

Diurnal Incontinence: Voluntary or involuntary loss of urine (wetting accidents) that occur during the daytime. Nighttime wetting, or nocturnal enuresis, can be associated with diurnal incontinence. Any form of wetting accidents either very small (moist underwear) or large is referred to as diurnal incontinence. The child may be completely unaware or intentionally have urinary wetting accidents.

Dysfunctional Elimination Syndrome: This literally means to have abnormal emptying of urine and/or stool (abnormal potty habits) after potty training. Children with this problem have a wide variety of signs, symptoms, and complaints. These children commonly have problems with never using the restroom, very frequently using the restroom, urgently going, holding and squatting, abdominal pain, soiled or stained underwear, blood in the urine, constipation and daytime or nighttime accidents of urine and or stool.

Dysfunctional Voiding: Children who have urinating problems without a medical explanation are referred to as having dysfunctional voiding. This medical term implies abnormal urinating habits without obvious problems with bowel movements. Now that bowel problems are known to commonly be associated with urinating problems, this term has been mostly replaced by dysfunctional elimination syndrome when referring to abnormal potty habits.

Dyssynergia: Urologists and Pediatric Urologists use this term to imply the conflicting actions of the bladder and the pelvic muscles. When the bladder or bowel tries to empty and the pelvic muscles or sphincters do not relax then there is a conflict and this results in pain, accidents, incomplete emptying, and any of the other complaints that are associated with abnormal potty habits.

Dysuria: Painful urination that is often described as burning or in a child's words having "needles" or "stinging". Dysuria is common in children with urinary tract infections, irritated private parts, and abnormal potty habits.

Encopresis: To have bowel accidents. Constipation is commonly associated with encopresis.

Enuresis: To have urinary accidents whether daytime or nighttime. Most people refer to nighttime wetting (nocturnal enuresis) as enuresis.

Fecal Impaction: A severe form of constipation can result in a child's inability to have a bowel movement. The child becomes blocked with stool and may require a very aggressive bowel program to relieve this problem.

Frequency: When a person uses the restroom often. Urinary frequency is one of the most common problems in children with abnormal potty habits.

Gross Hematuria: To have blood in the urine that is visible. Gross hematuria usually implies some form of underlying problem such as stones, urinary tract infections, birth defects of the urinary system, and trauma.

Hematuria: Blood in the urine that is either visible or invisible.

Hesitancy: When one has a delay or difficulty starting a urinary stream.

Incontinence: To leak urine or stool. Usually refers to leaking urine.

Kidney: The body organ that filters blood and makes urine. The kidney regulates toxins in our bloodstream, body water, blood production, and blood pressure.

Microscopic Hematuria: Blood in the urine that is not seen with the naked eye. Blood can be detected in the urine by using a microscope or performing a "dip stick" test.

Nocturnal Enuresis: To have urinary accidents at night. Also called bedwetting.

Pediatric Gastroenterologist: A physician who has completed medical school, a pediatric residency, and a pediatric gastroenterology fellowship (pediatric GI). Pediatric residencies are typically 3-4 years and the fellowship is an additional 2-3 years. Pediatric gastroenterologists diagnose, manage, and treat children with swallowing, digestive, intestinal, and liver problems. The most common problems they treat are Chrohn's disease, gastroesophageal reflux, constipation, abdominal pain and abnormal liver function.

Pediatric Nephrologist: A physician who has completed medical school, a pediatric residency, and a pediatric nephrology fellowship. The pediatric residency is usually 3-4 years. The pediatric nephrology fellowship is an additional 1-3 years. Pediatric nephrologists diagnose, manage, and treat children with problems related to the urinary system. Most commonly

they treat children with abnormal urine tests, kidney failure, and kidney transplants.

Pediatric Urologist: A physician who has completed medical school, a urology residency, and a pediatric urology fellowship. The urologic residency training is typically 5-6 years and includes 1-2 years of general surgery training. The pediatric urology fellowship is an additional 1-2 years. Pediatric urologists diagnose, treat and manage problems related to the adrenal glands, kidneys, bladder, and urinary tract system including the ureters and urethra and private parts (genitalia) in children. The most common problems a pediatric urologist treats are blockages in the urinary tract, vesicoureteral reflux, urinary tract infections, birth defects involving the urinary system, undescended testicles, and genital abnormalities including intersex disorders. Potty training, abnormal potty habits (dysfunctional elimination syndrome), bedwetting and constipation are some of the most common conditions that a pediatric urologist treats.

Pyelonephritis: An infection involving the kidney that is usually caused by bacteria. Children with pyelonephritis usually present with back pain, fever greater than 101°, and poor appetite to include nausea and vomiting.

Rectum: The final portion of lower colon that controls the flow of stool to the outside world.

Sensory Integration Dysfunction: A neurological disorder that results in either a hyposensitivity or hypersensitivity in varying degrees to the sense of touch or any of the other senses.

Sphincter: A muscle that wraps around the urethra and rectum. This muscle can tighten and hold urine in the bladder or stool in the colon. There are several sphincters. Some sphincters can be tightened and contracted by a child when they do not want to use the restroom. Sphincters are supposed to be relaxed and open when one pees or poops.

Stress Incontinence: To experience urinary leakage when coughing, laughing, or lifting. Children who leak with laughter are referred to as having "giggle incontinence".

Ureter: This is the very small tube that drains urine from the kidney as it empties into the bladder.

Urethra: This is the passageway from the bladder to the outside world. The urethra is a tube structure that is short in girls and longer in boys. The urinary sphincters and pelvic muscles wrap around the urethra and coordinate their activity with the bladder to either allow storage or emptying of urine.

Urge Incontinence: To have a sudden urge to use the restroom followed by urinary leakage. Children and parents will describe that they do not get to the restroom quick enough before having an accident.

Urgency: To have a sudden urge to urinate (and possibly have a bowel movement).

Urinary Tract Infection (UTI'S): Any infection involving the urinary tract, which most commonly is either kidney or bladder. Infections involving the ureters (kidney tubes) and urethra (bladder tube) are also considered urinary tract infections. Urinary tract infection is a very broad term. Many people will use the term UTI when explaining a pyelonephritis (kidney) or cystitis (bladder) infection.

Voiding: The act of urinating. The medical term for peeing.

RESOURCES

For Children

Caillou-Potty Time
Joceline Sanschagrin and Helene Desputeaux
Chouette Publishing 2000

Everbody Poops
Taro Gomi and Amanda Mayer Stinchecum
Kane/Miller Publisher 1993

I Can Go Potty
Bonnie Worth and David Prebenna (illustrator)
Bonnie Worth 1999

My Big Girl Potty and *My Big Boy Potty*
Joanna Cole and Maxie Chambliss
HarperCollins Juvenile Books 2000

Once Upon a Potty
Alona Frankel
HarperCollins Juvenile Books 1999

The Potty Book for Boys
Alissa S. Capucilli and Dorothy Stott (illustrator)
Barrons Educational Series 2000

The Princess and the Potty
Wendy Lewison
Aladdin Paperbacks 1998

Toilet Learning: the picture book technique for children and parents
Alison Mack
Little, Brown and Company 1978

Uh Oh! Gotta Go!
Bob McGrath and Shelley Dieterichs (illustrator)
Barrons Juveniles 1996

What Do You Do With a Potty?: An Important Pop-up Book
Marianne Bogardt and Maxie Chambliss (illustrator)
Golden Books 1994

What to Expect When You Use the Potty
Heidi Murkoff and Laura Rader (illustrator)
HarperCollins Juvenile Books 2000

When You've Got to Go!
Janelle Kriegman, Mitchell Kriegman and Kathryn Mitter (illustrator)
Simon Spotlight 2000

Your New Potty
Joanna Cole and Margaret Miller (photographer)
Morrow Junior Books 1989

For Parents

Guide to Toilet Training
Mark Wolraich and Sherill Tippins
Bantam Books 2003

Potty Training for Dummies
Diane Stafford and Jennifer Shoquist
Wiley Publishing 2002

The Everything Potty Training Book
Linda Sonna
Adams Media 2003

Toilet Learning: the picture book technique for children and parents
Alison Mack
Little, Brown and Company 1978

Toilet Training: a practical guide to daytime and nighttime training
Vicki Lansky
Book Peddlers 2002

Toilet Training for Individuals with Autism & Related Disorders
Maria Wheeler
Future Horizons 1998

Toilet Training in Less Than a Day
Nathan H. Azrin and Richard M. Foxx
Pocket Books 1974

POTTYMD.COM
Home of the Potty Monkey™

Center of Excellence for:
Potty Training
Potty Problems After Training
Bedwetting
Constipation/Encopresis

Exclusive PottyMD Products

Potty Monkey™ Products
Calendar/Reward Systems
Tinkle Timers™

Urine/Bowel Monitoring Kit
Books (all topics)
Counseling

Other products available from PottyMD:

Bedwetting Alarms
Potties
Videos

Watches for Timed Voiding
Potty Seats
Waterproof Bedding

And Much, Much More!

PottyMD
Helping kids to stop and to go.

PottyMD.com 1-877-PottyMD